A Keepsake

BOSTON

Arthur P. Richmond

Schiffer Publishing Ltd

4880 Lower Valley Road • Atglen, PA 19310

To Ava Elizabeth

INTRODUCTION

Boston is a modern city with old-world roots, and these images capture its 400-year-old charm. Visit Faneuil Hall, the Old North Church, the Swan Boats, the waterfront with its distinctive architecture, the universities, and the diverse neighborhoods that bring vitality and energy to the city. From the famous Boston harbor to the many historical and contemporary attractions in the city itself, Boston offers visitors a magnificent experience.

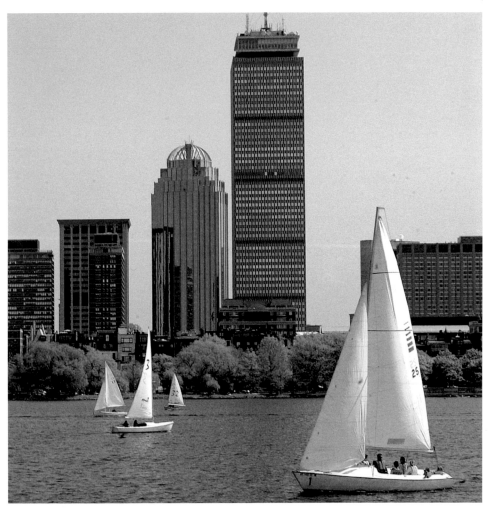

Sailing on the Charles River.

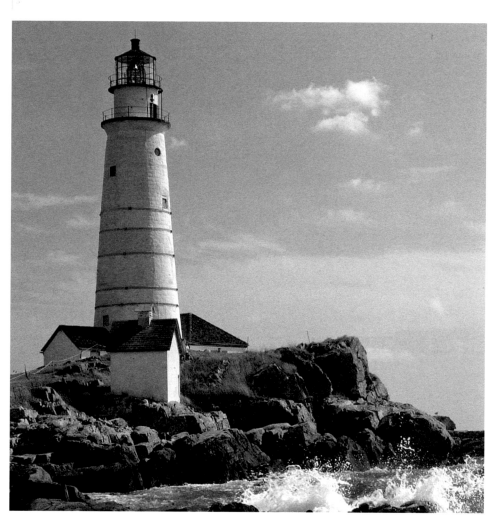

Boston Light was built in 1716.

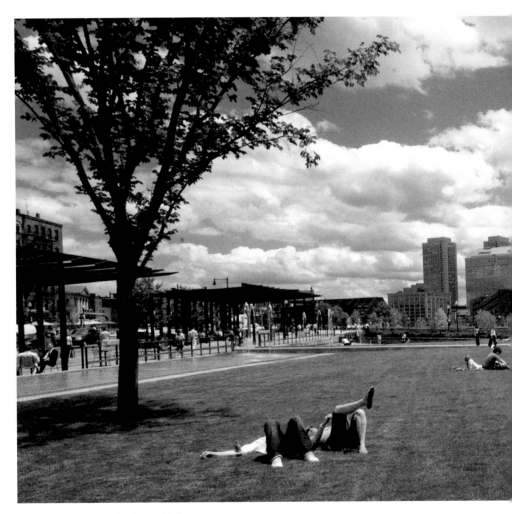

The Greenway replaced a former highway.

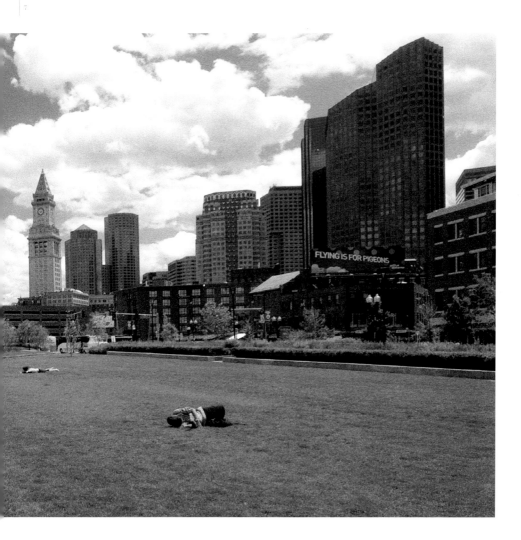

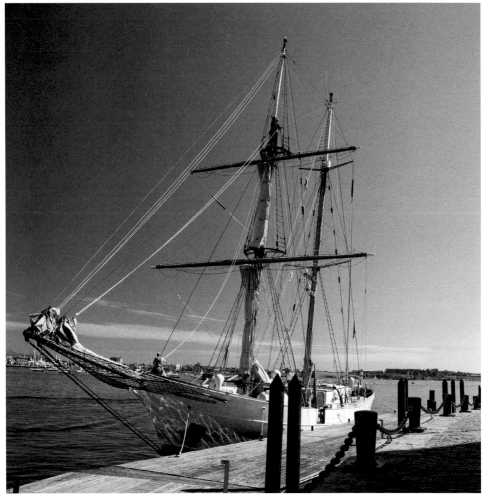

A vintage sailboat tied up at a downtown dock.

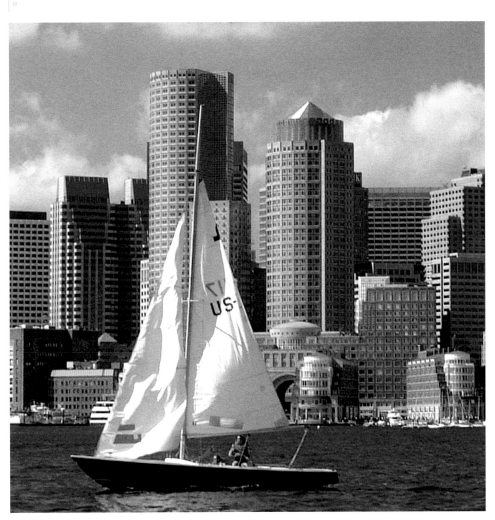

Sailing is popular in the inner harbor.

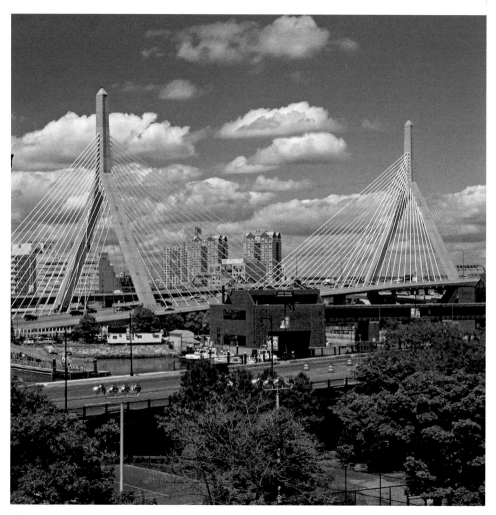

The Leonard Zakim Bunker Hill Memorial Bridge.

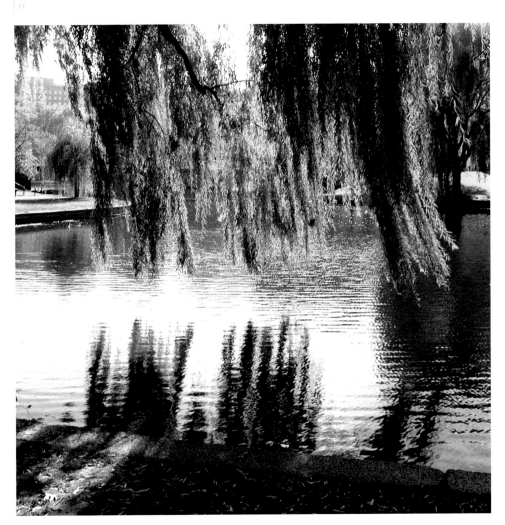

Willows overhang the Public Garden lagoon.

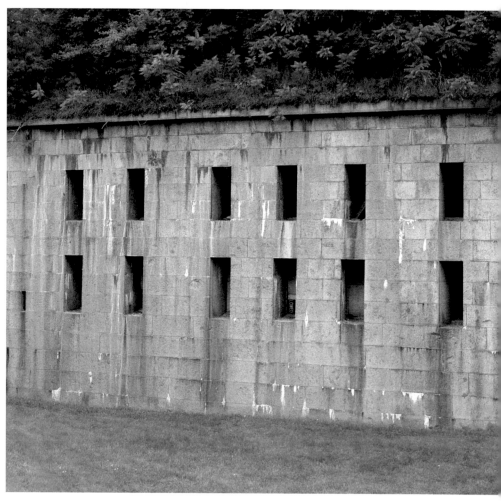

Fort Warren in the outer harbor was built in 1833.

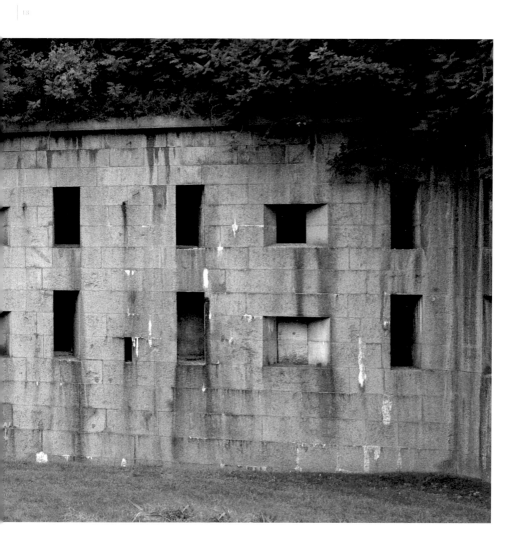

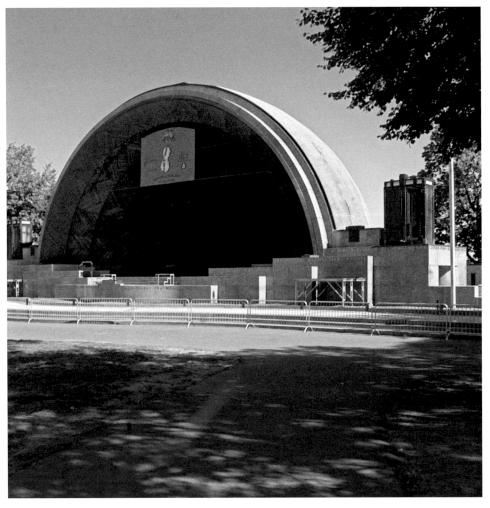

The Edward A. Hatch Shell on the Charles River Esplanade.

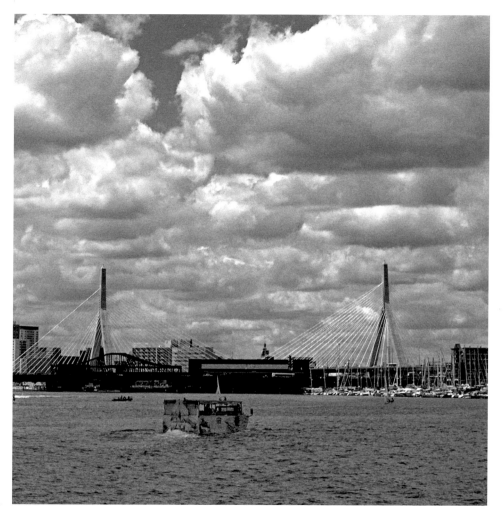

Ferries crisscross the harbor.

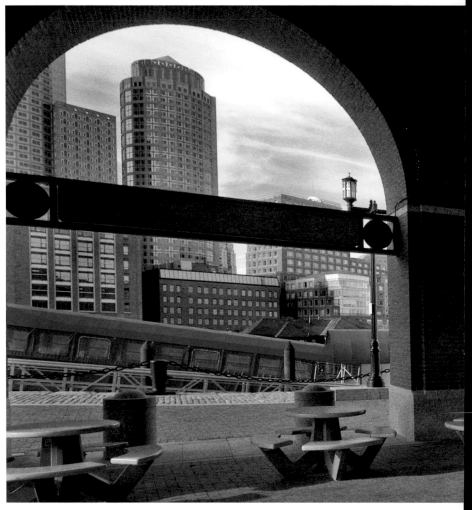

A view of downtown Boston from the courthouse.

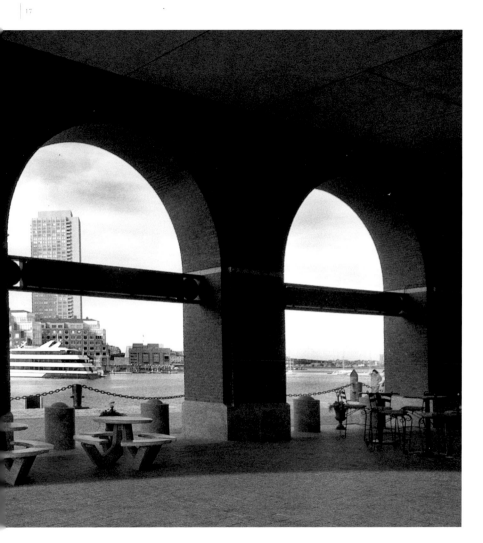

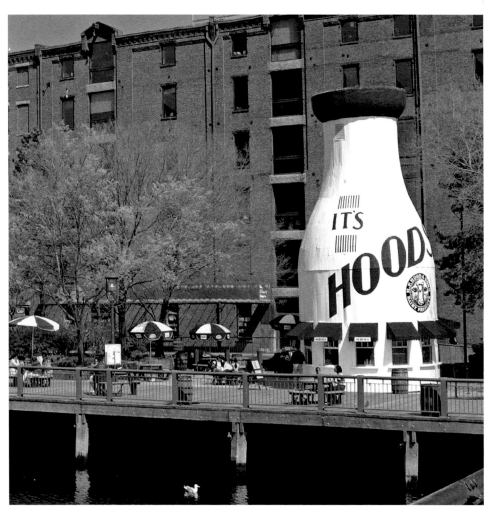

The iconic milk bottle near the Children's Museum.

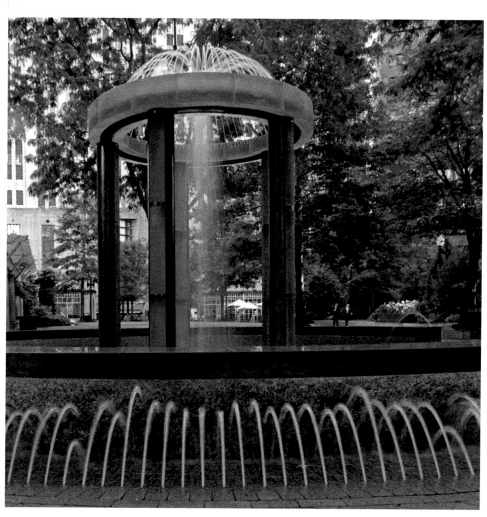

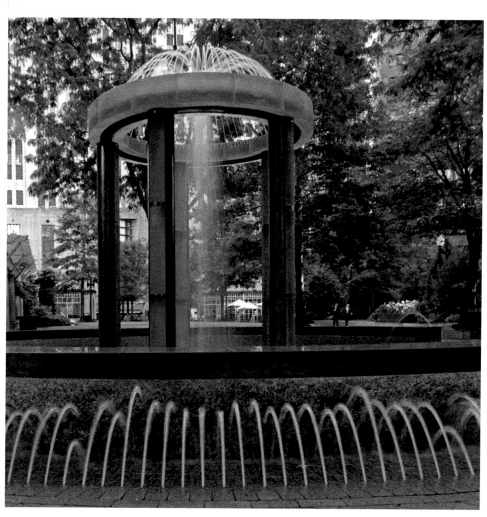

A fountain in Post Office Square.

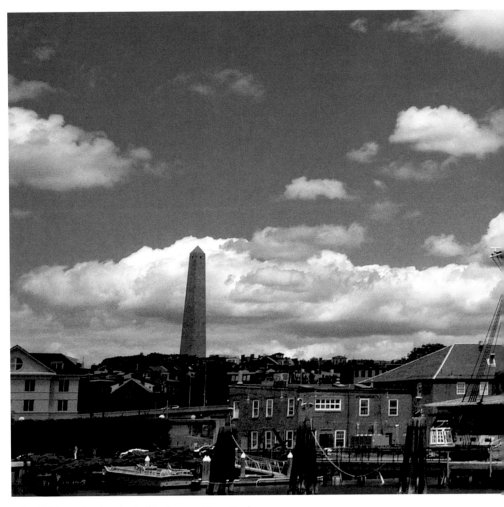

The USS Constitution *in the Charlestown Navy Yard.*

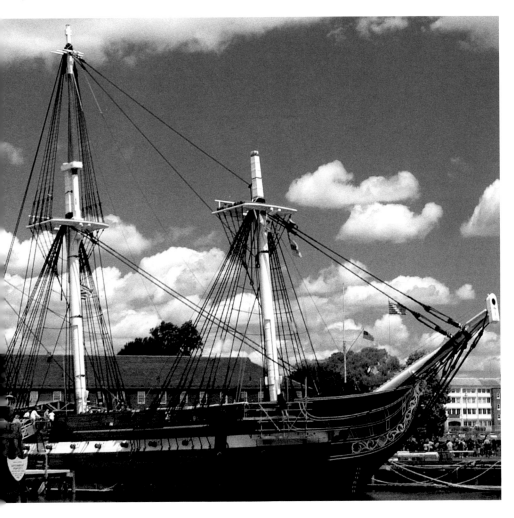

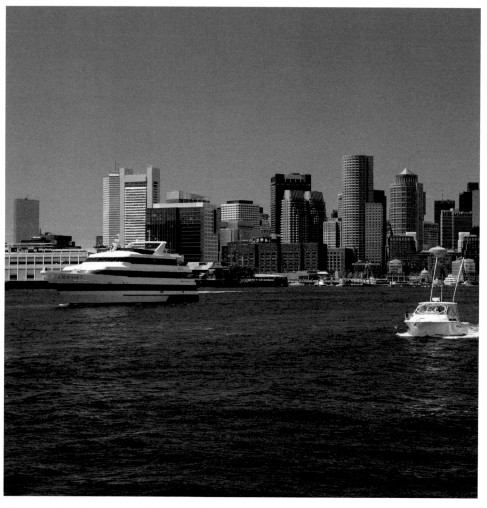

Pleasure craft and dinner cruise ships sail the harbor.

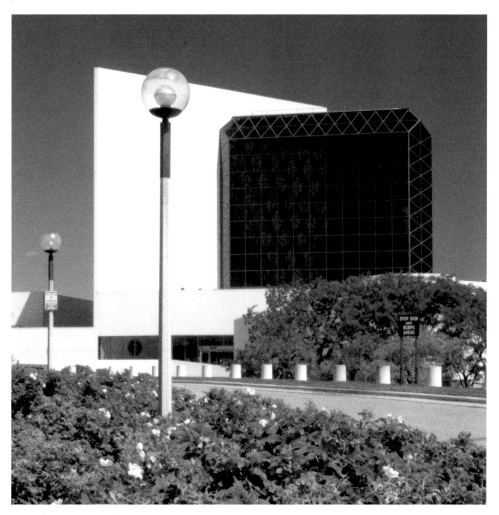

The John F. Kennedy Library.

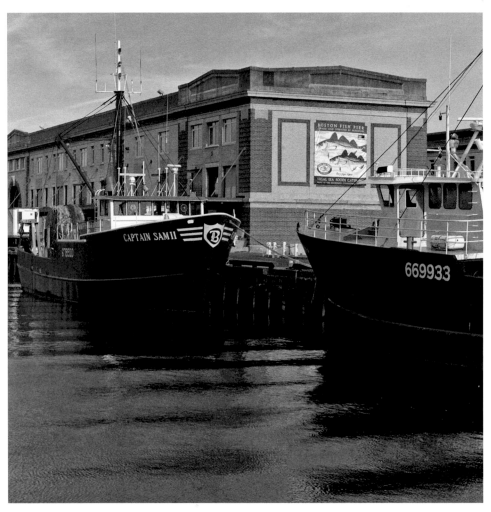

Trawlers at the Boston Fish Pier.

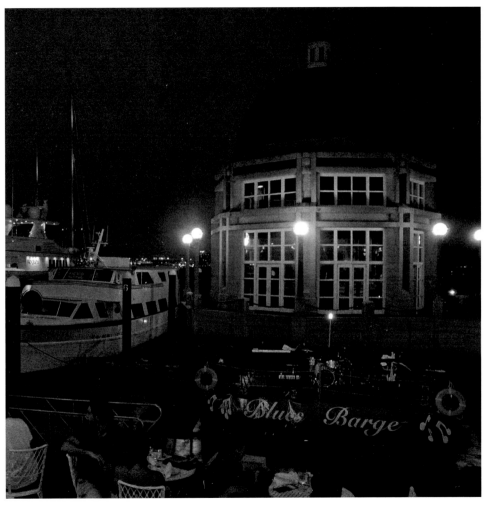

Dining and music highlight the activities at the Pavilion.

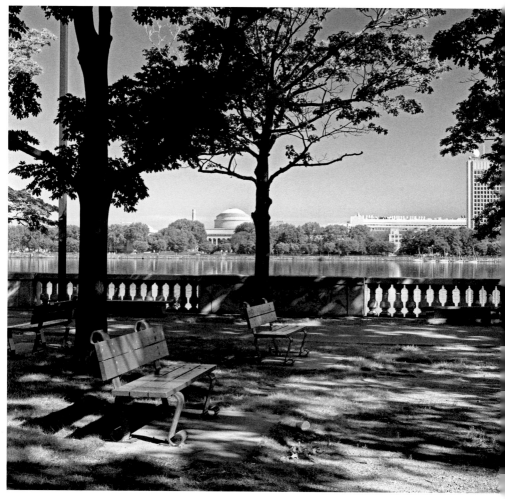

The Esplanade runs along the banks of the Charles River.

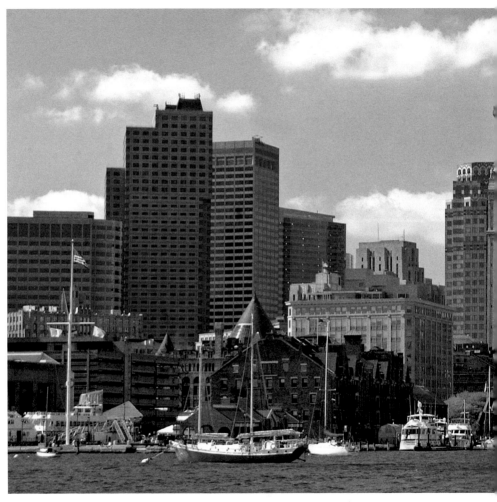

A variety of vessels dock in the harbor.

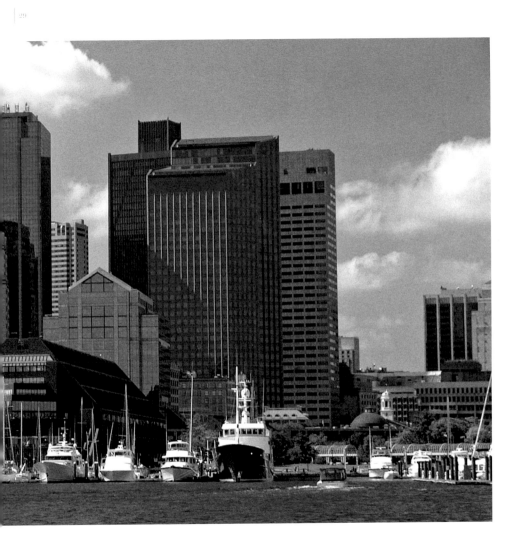

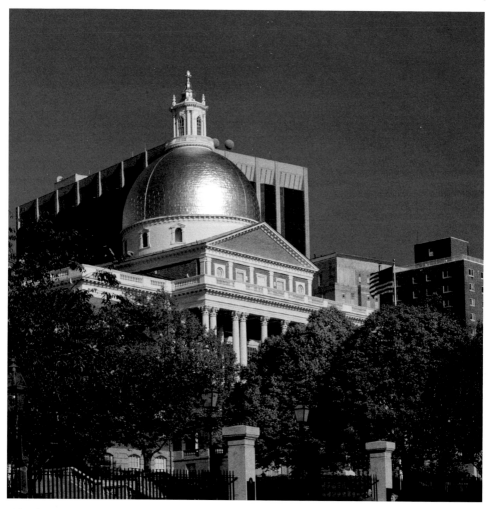

A bright summer day at the State House.

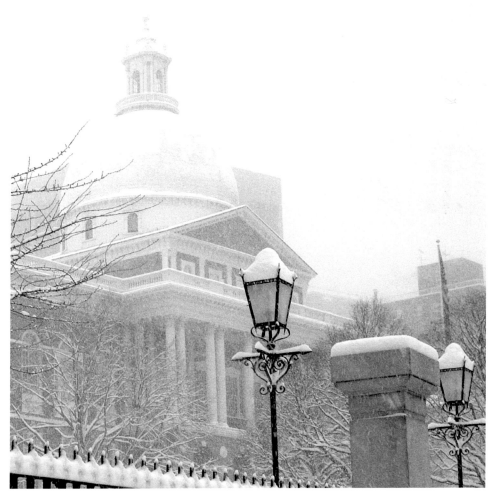

Snow covers the State House dome.

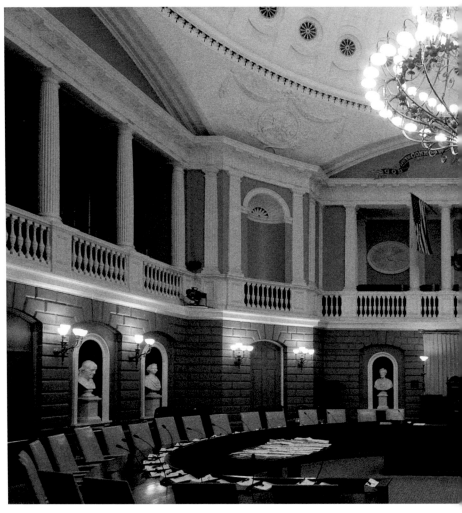

The senate chamber in the State House.

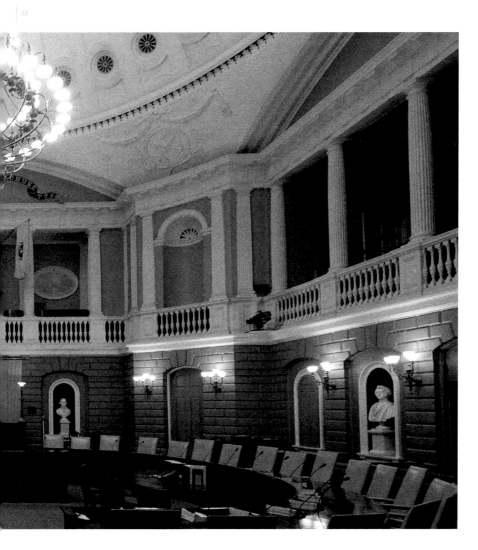

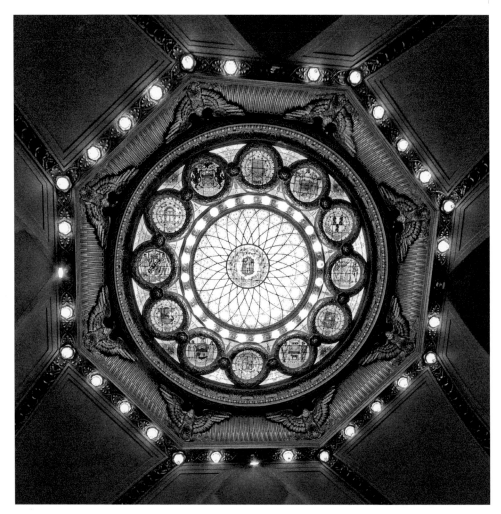

An inside view of the dome.

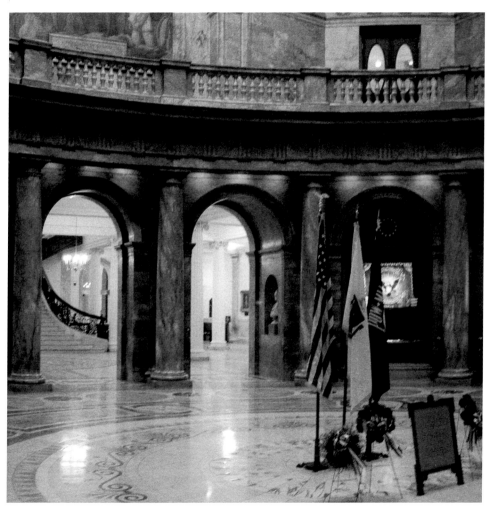

The lobby inside the State House.

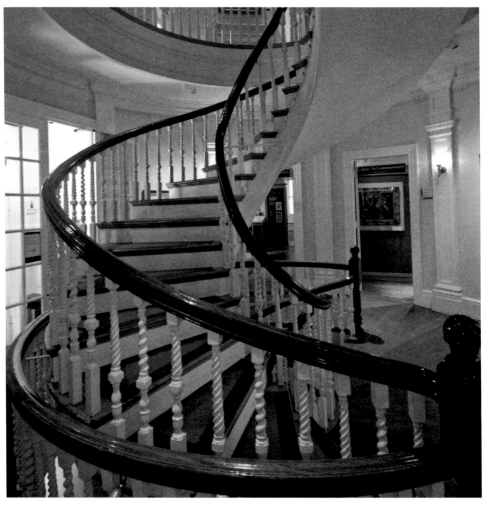

In the old State House, magnificent stairs lead to . . .

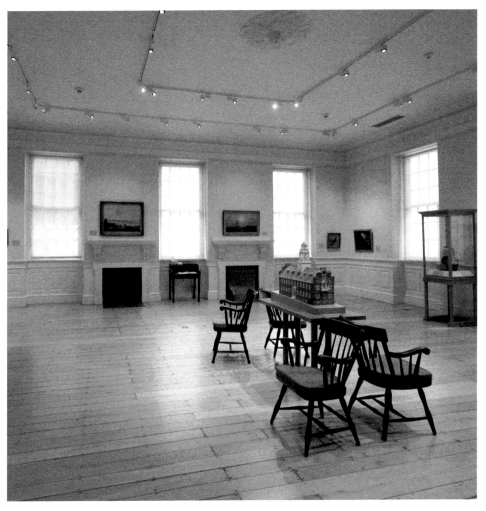

. . . this museum room.

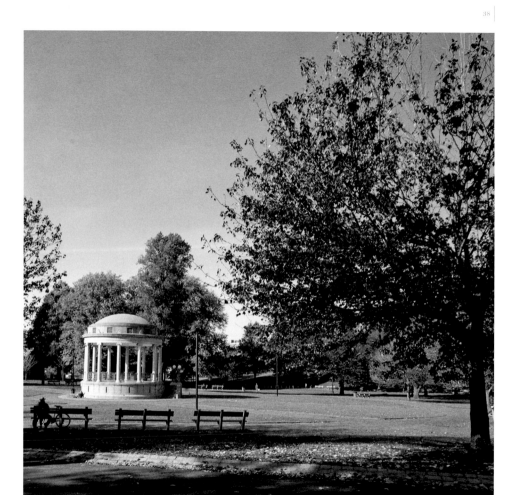

The Parkman Bandstand on the Common.

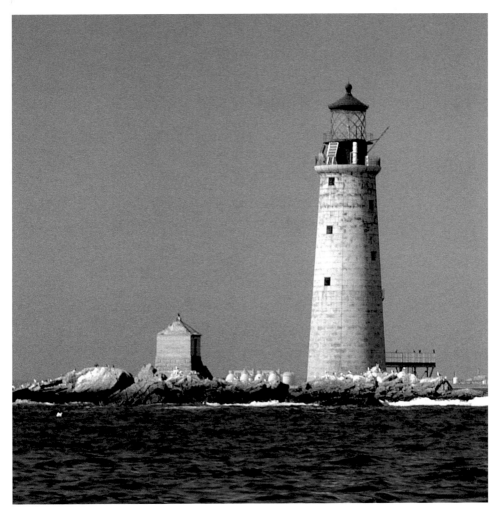

As mariners approach Boston, the first lighthouse they encounter is Graves Light.

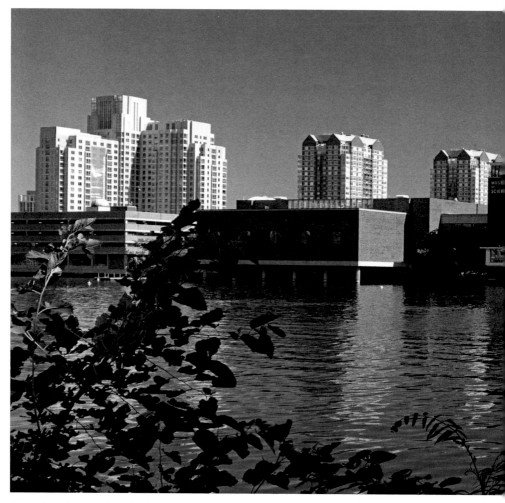

The Science Museum is on the shore of the Charles River.

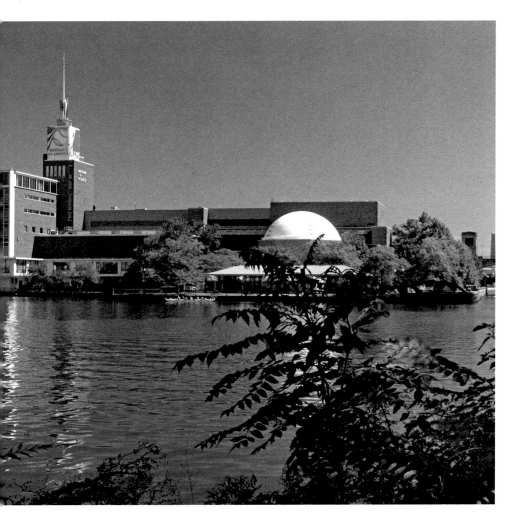

The Swan Boats remain a popular tourist attraction.

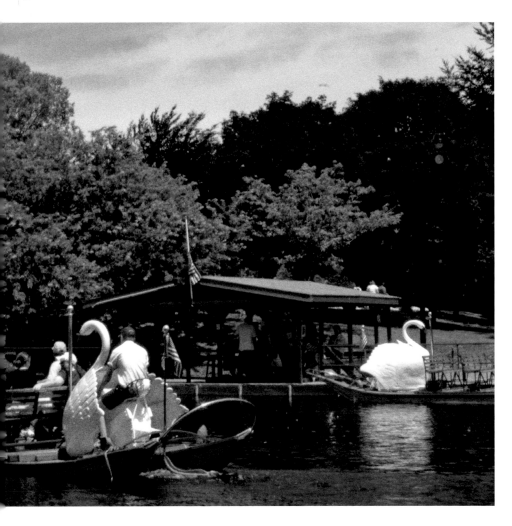

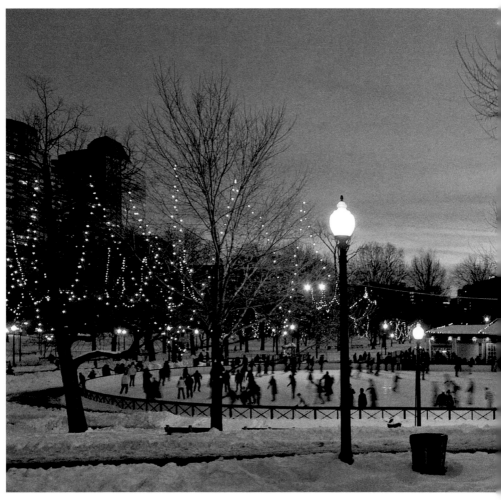

The Frog Pond on the Common provides a place to skate.

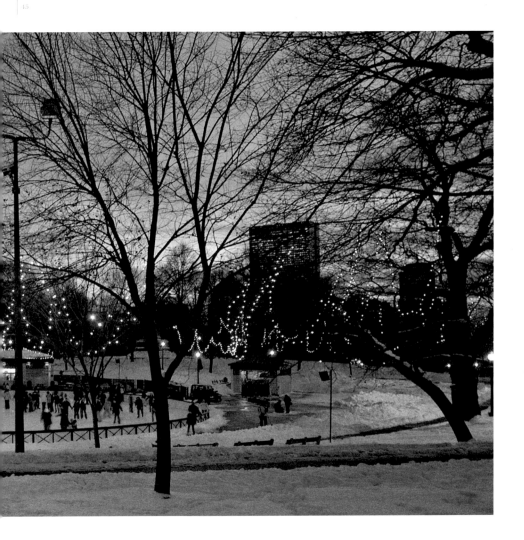

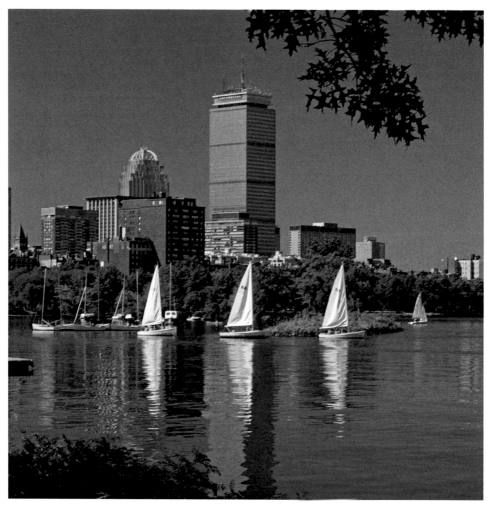

Clubs and schools offer sailing on the Charles River.

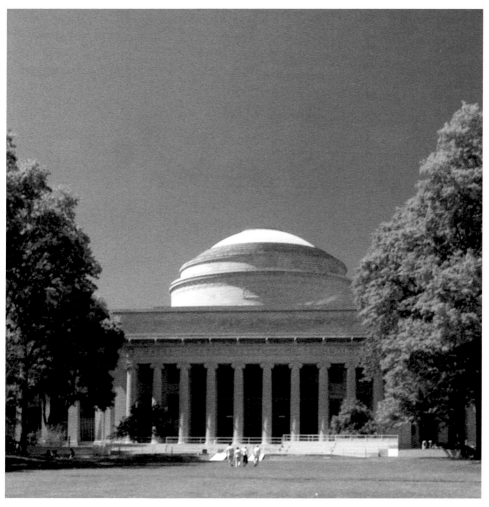

The distinctive dome of MIT, Massachusetts Institute of Technology.

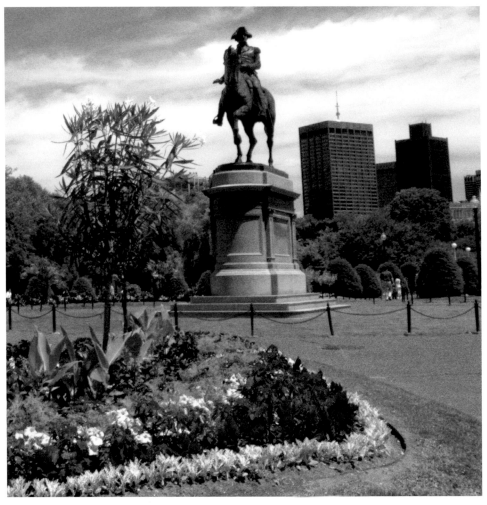

The statue of George Washington is imposing in summer . . .

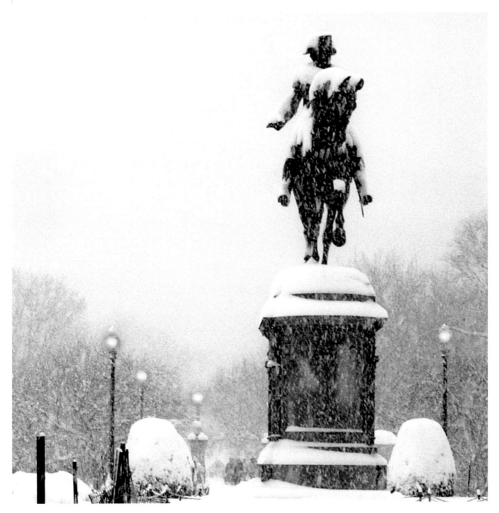

. . . and in winter.

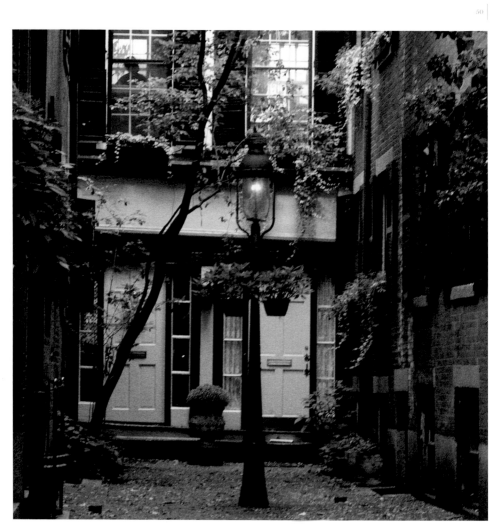

A quiet walkway on Beacon Hill.

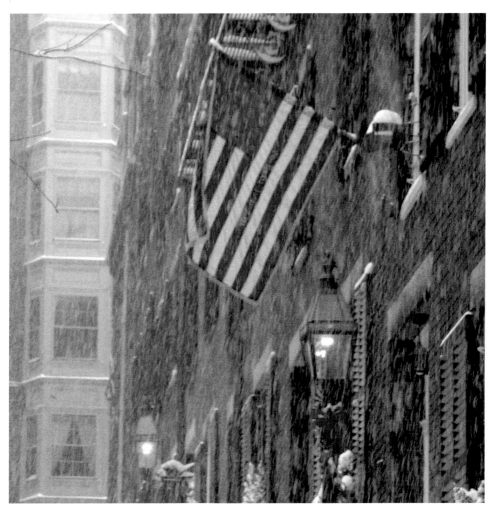

Acorn Street on Beacon Hill.

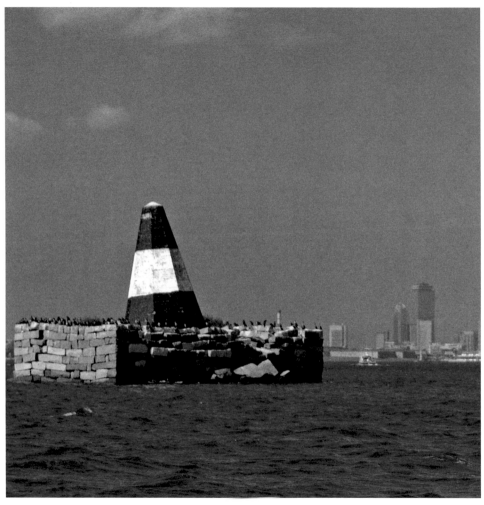

Nix's Mate is a day marker in the shipping channel.

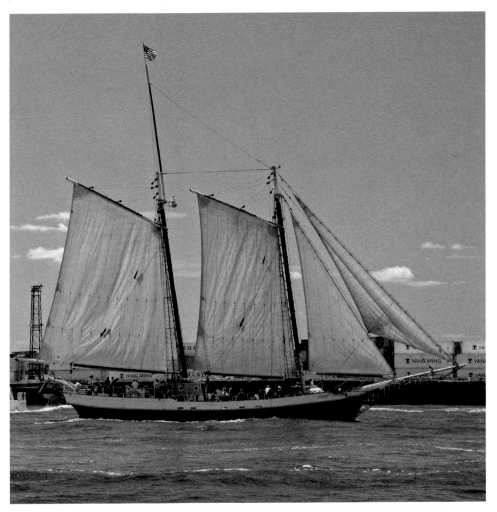

Tourists enjoy sailing in the harbor on a vintage sailboat.

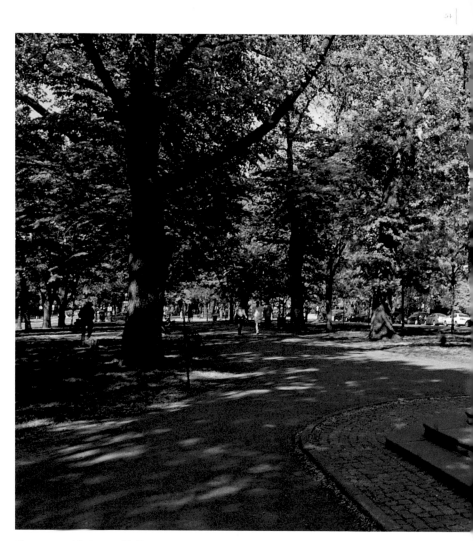

Commonwealth Avenue Mall.

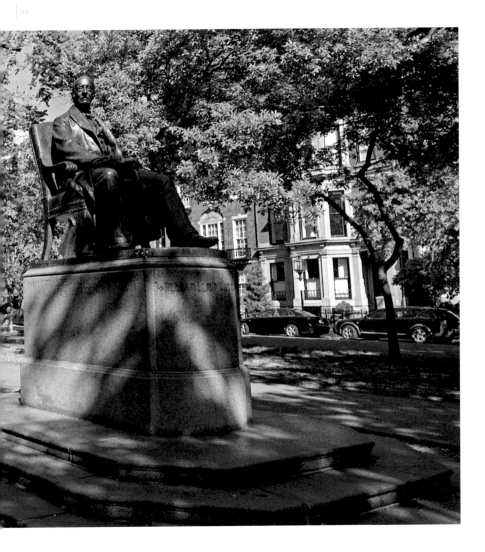

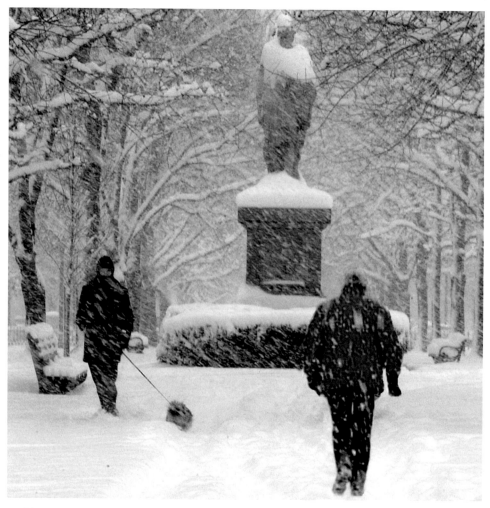

Walking on Commonwealth Avenue Mall.

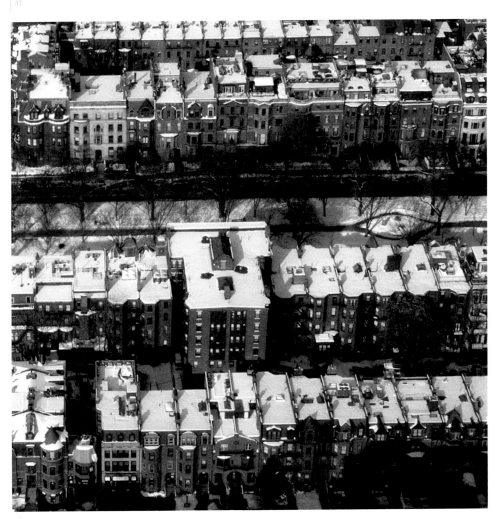

The Mall viewed from the Prudential Center building.

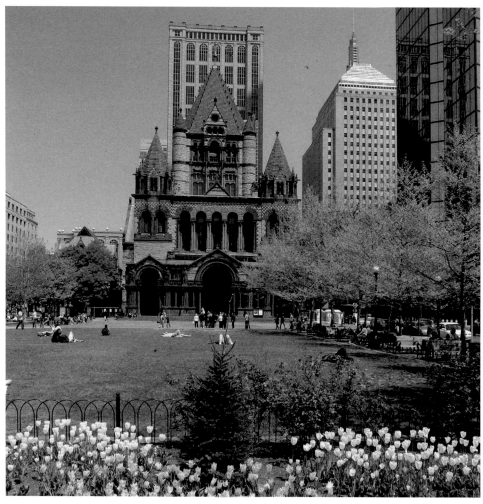

Trinity Church in spring, overlooking Copley Plaza . . .

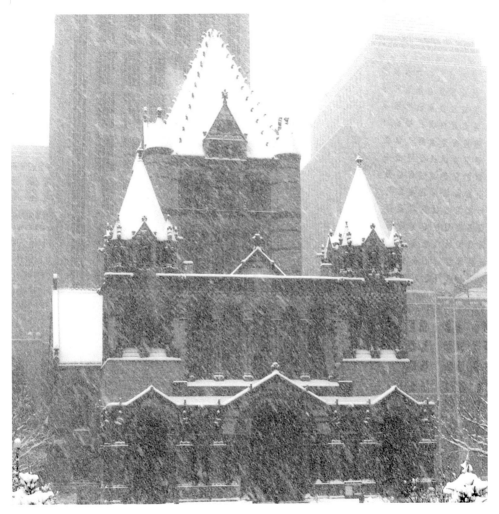

. . . and on a winter's day.

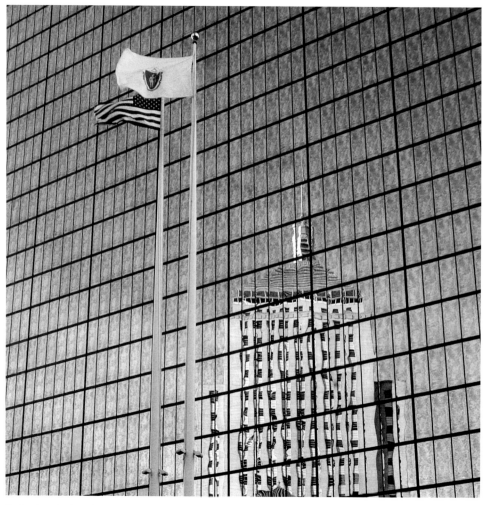

Reflections in the John Hancock Tower.

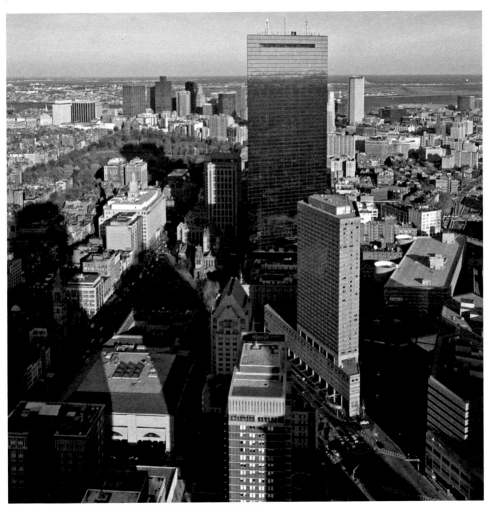

The John Hancock Tower from the Prudential Center.

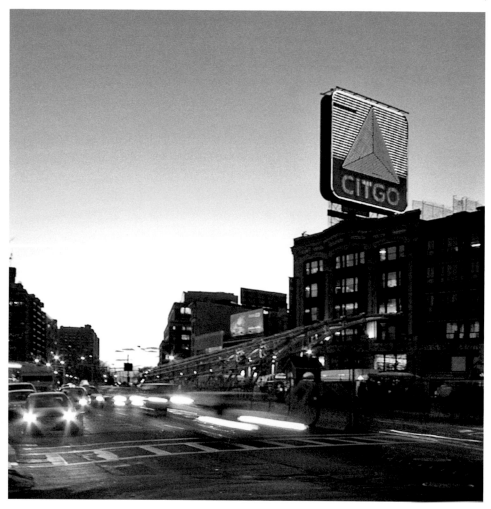

The legendary Citgo sign in Kenmore Square.

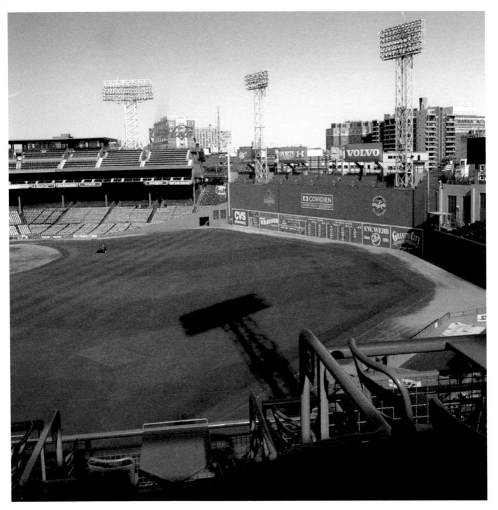

Fenway Park, showing the Green Monster.

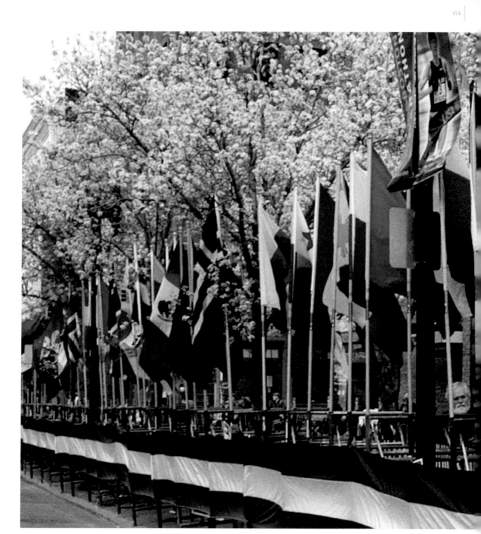

Flags line the street during the Boston Marathon.

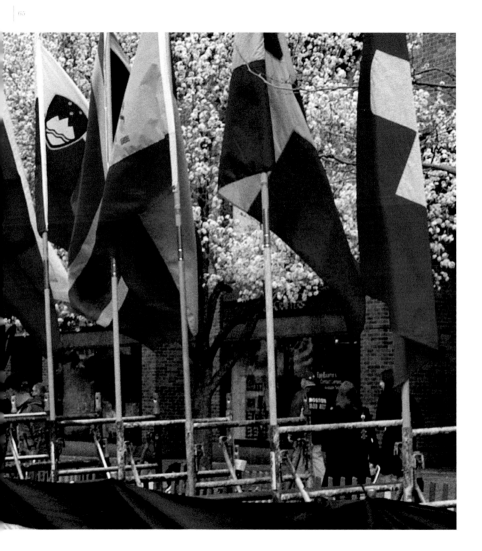

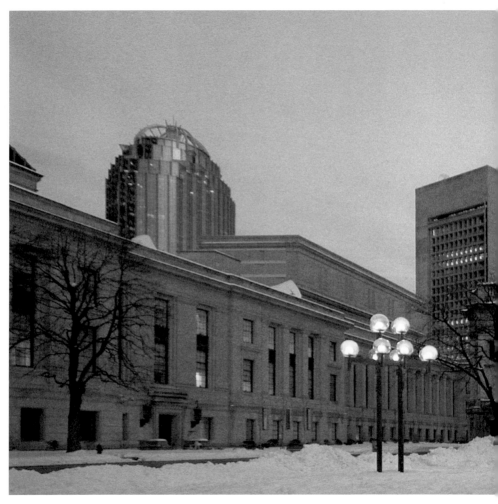

The Christian Science Plaza.

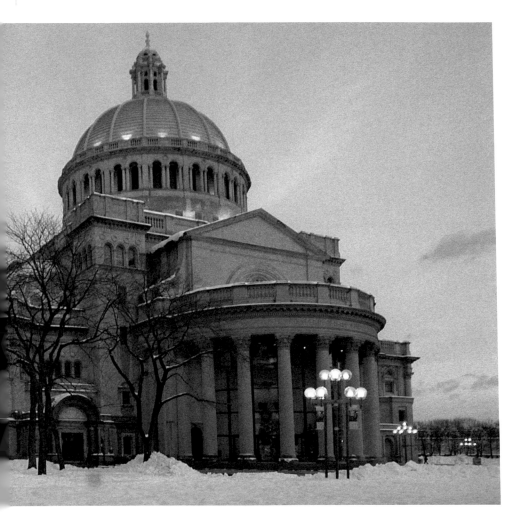

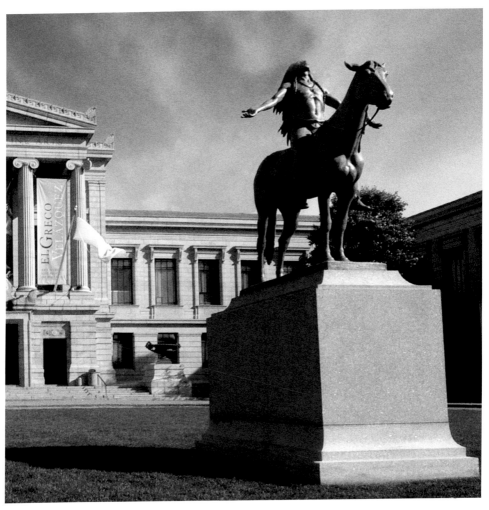

The statue Appeal to the Great Spirit *stands outside the Museum of Fine Arts.*

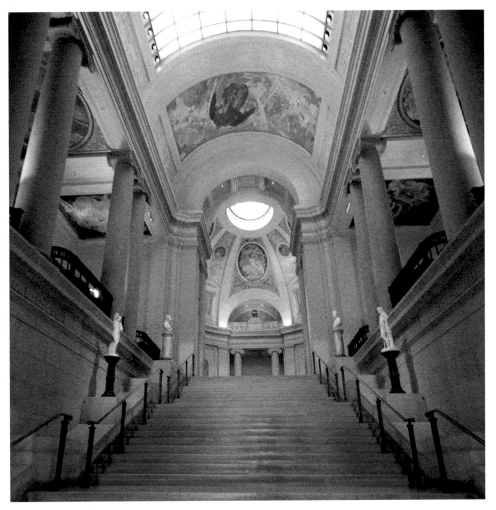

Stairs lead into the halls of the Museum of Fine Arts.

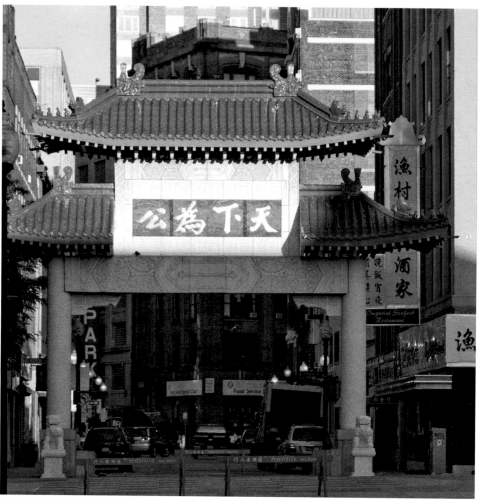

An entrance to Chinatown.

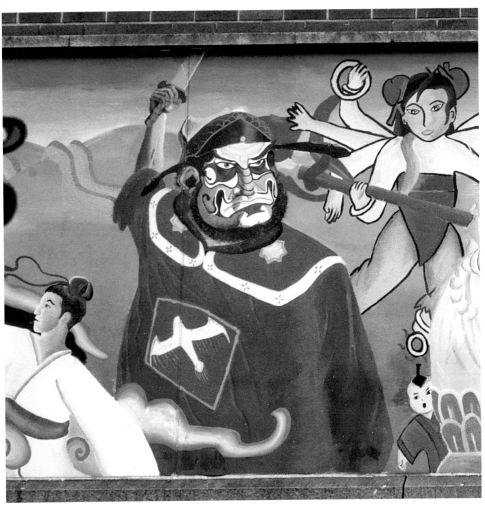

Murals decorate walls in Chinatown.

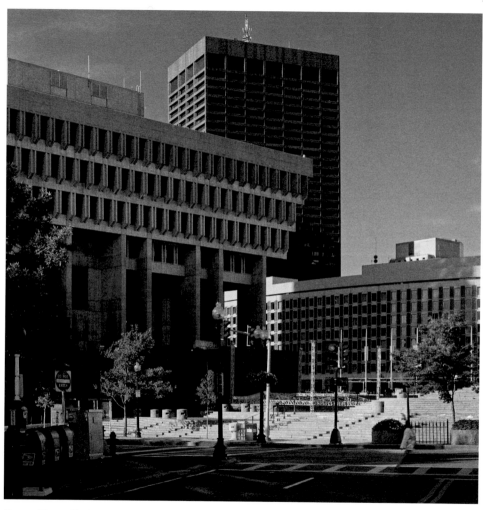

Boston City Hall Plaza.

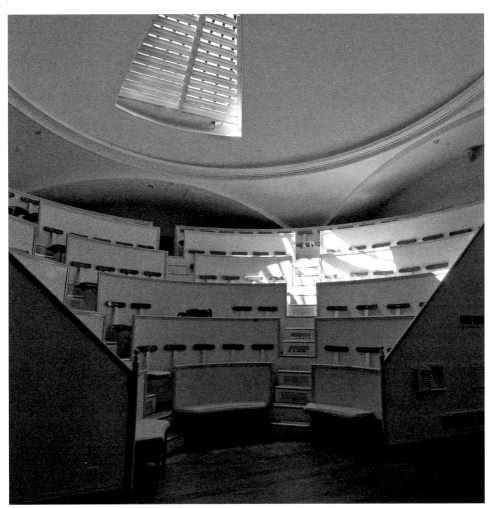

The Ether Dome at Massachusetts General Hospital.

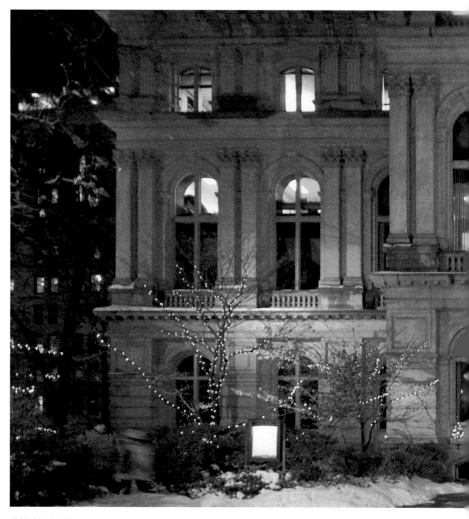

Old City Hall.

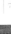
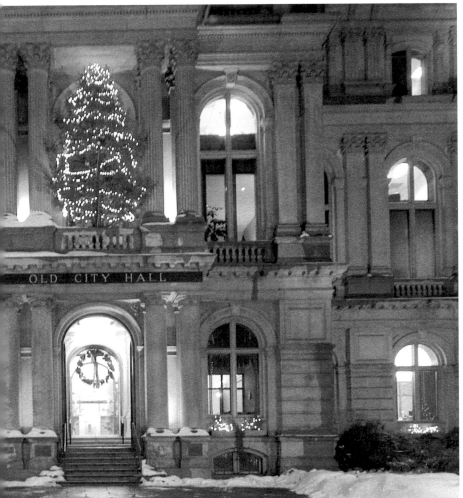

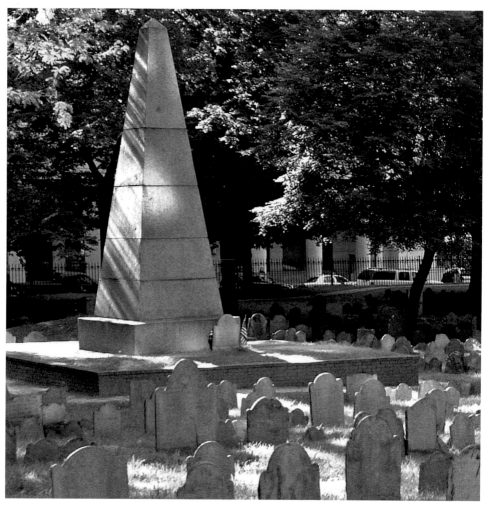

The Old Granary Burial Ground.

A hawk watches over the cemetery.

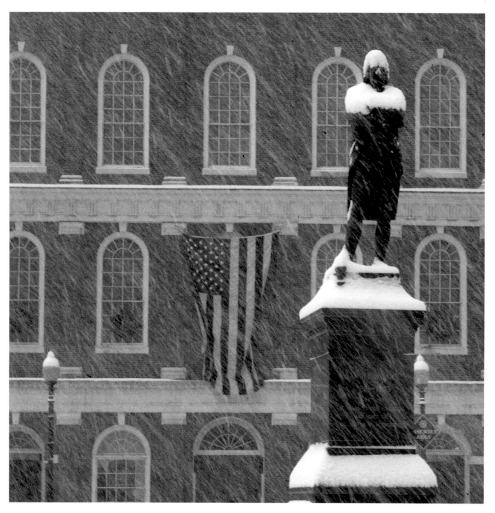

A statue of Samuel Adams, in front of Faneuil Hall.

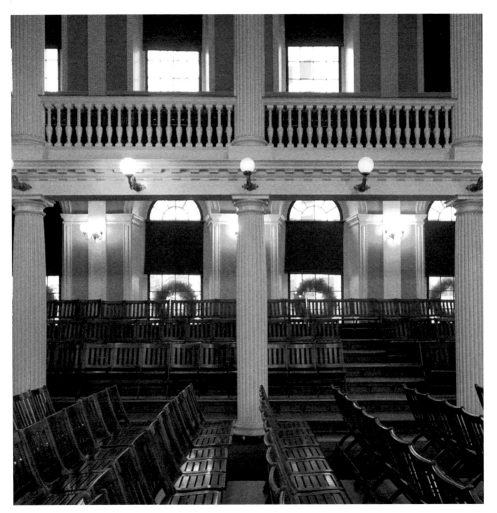

Inside the famous hall.

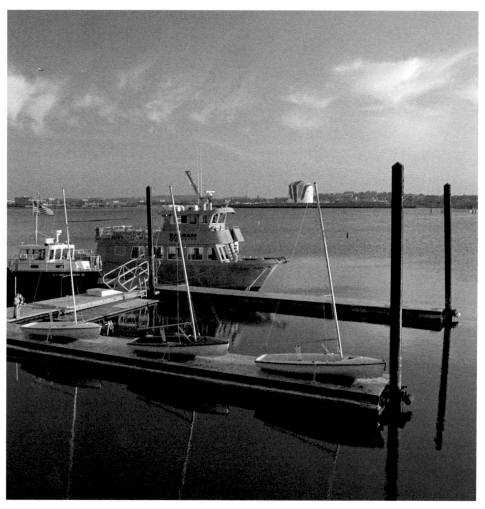

The docks at UMass Boston.

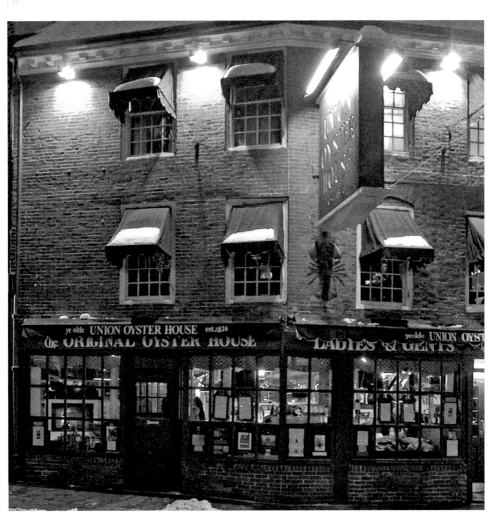

The Union Oyster House is the nation's oldest restaurant.

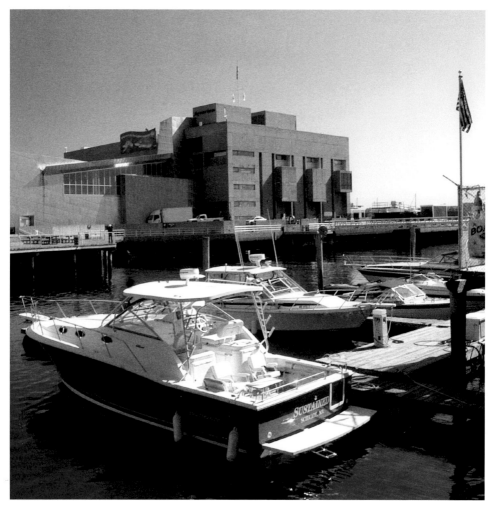

The Boston Aquarium on the waterfront.

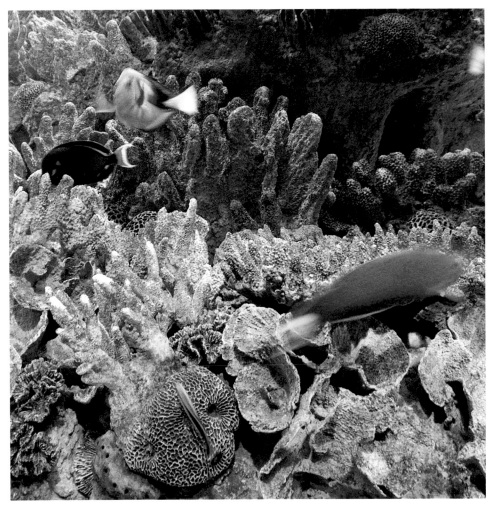

Brightly colored fish and coral in one of the tanks.

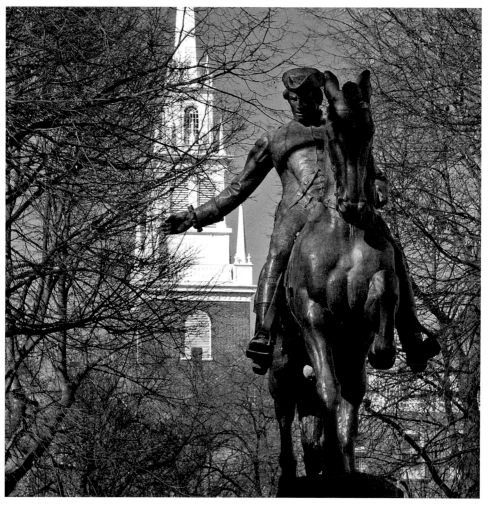

Paul Revere and the Old North Church.

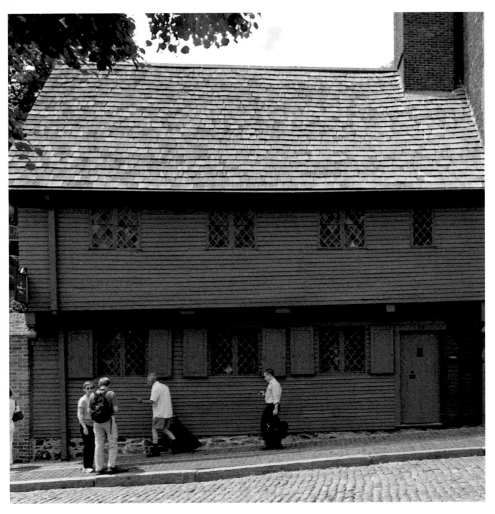

Nearby is Paul Revere's House, now a museum.

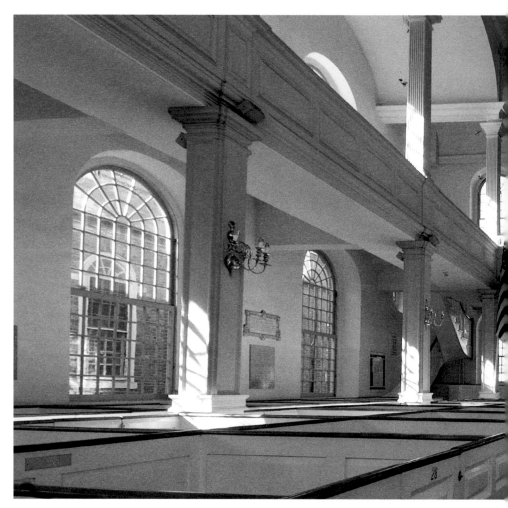

The sanctuary of the Old North Church.

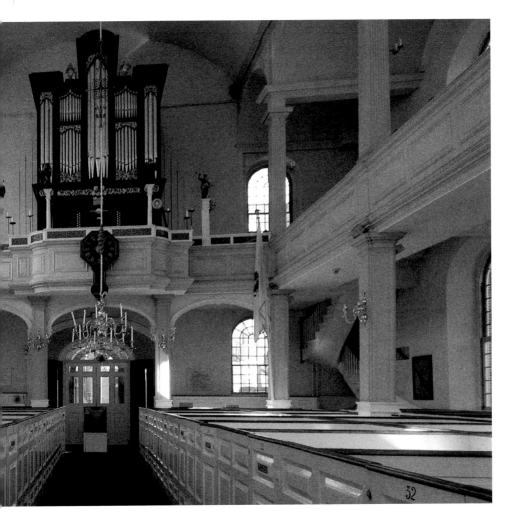

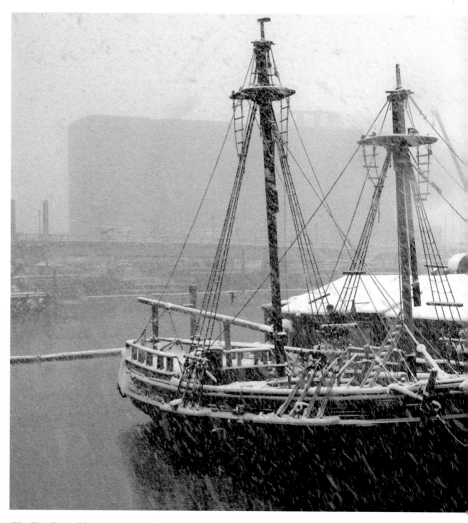

The Tea Party Ship.

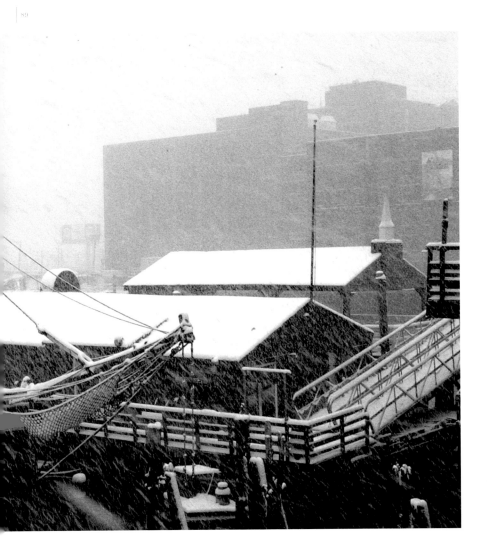

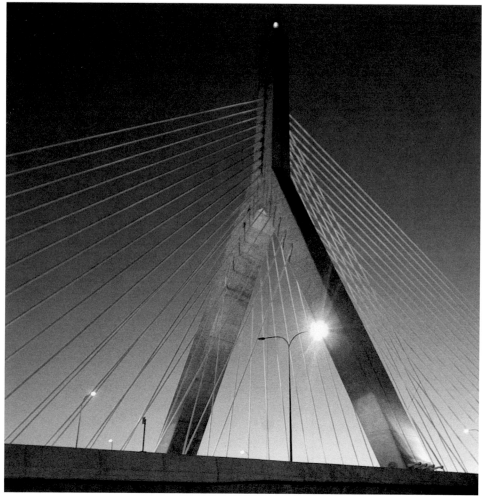

The towers of the Leonard Zakim Bunker Hill Memorial Bridge symbolize Bunker Hill Monument.

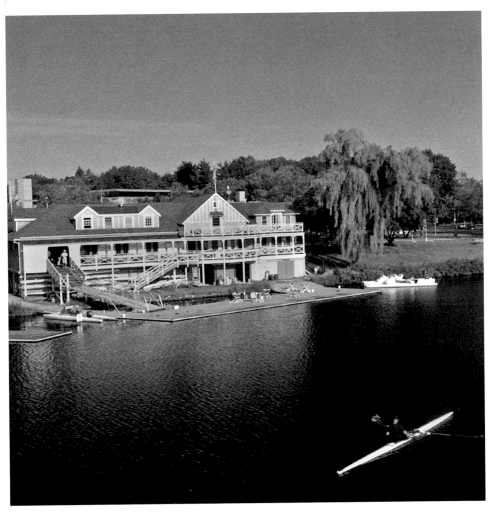

Many universities have boathouses on the river.

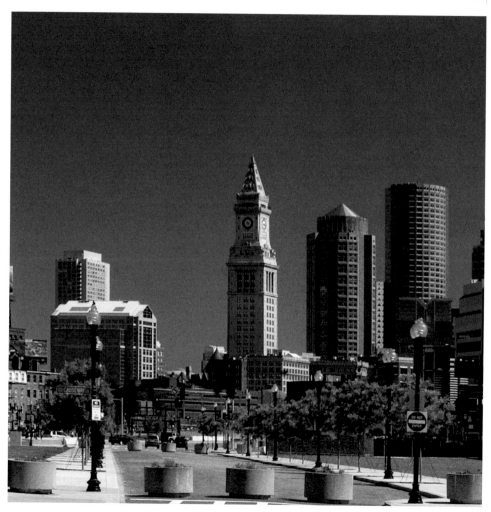

The Custom House is distinctive in the skyline.

Children enjoy the fountains on the Greenway.

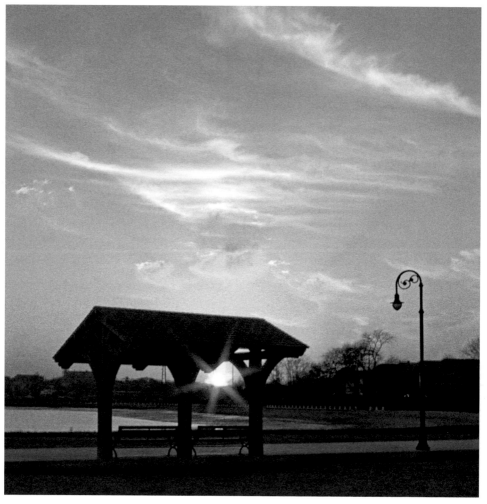

Malibu Beach at sunset.

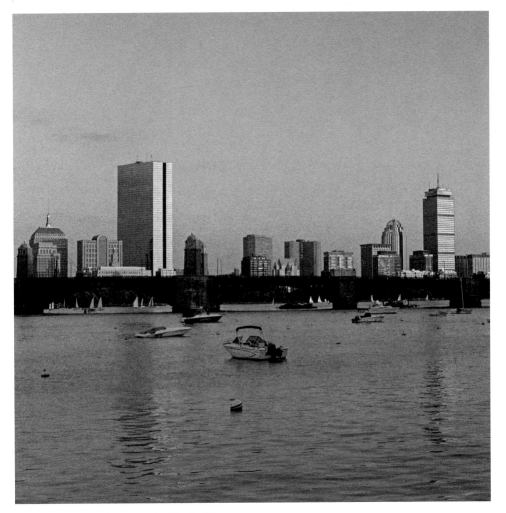

The Longfellow Bridge crosses the Charles River.

*Arthur P. Richmond has been a photographer for
more than fifty years. He is the author of more
than a dozen books, and his images are also
found in calendars and postcards, as well as on
display at several galleries in Massachusetts.*

Other Schiffer Books by the Author:
Massachusetts Lighthouses and Lightships,
ISBN 978-0-7643-4853-2
Boston Wide, ISBN 978-0-7643-3273-9
Cape Cod along the Shore: A Keepsake,
ISBN 978-0-7643-5160-0

Designed by Molly Shields
Type set in Bell MT

ISBN: 978-0-7643-5056-6
Printed in China

Published by Schiffer Publishing, Ltd.
4880 Lower Valley Road
Atglen, PA 19310
Phone: (610) 593-1777; Fax: (610) 593-2002
E-mail: Info@schifferbooks.com
Web: www.schifferbooks.com

For our complete selection of fine books on this and
related subjects, please visit our website at www.
schifferbooks.com. You may also write for a free catalog.

Schiffer Publishing's titles are available at special discounts
for bulk purchases for sales promotions or premiums.
Special editions, including personalized covers, corporate
imprints, and excerpts, can be created in large quantities
for special needs. For more information, contact the publisher.

We are always looking for people to write books on new
and related subjects. If you have an idea for a book,
please contact us at proposals@schifferbooks.com.